theatre O Your Vic

THE SECRET AGENT

Created by theatre O and Matthew Hurt with the company

A theatre O / Young Vic co-production

Co-commissioned by Warwick Arts Centre and supported by the Arts Council England, Shoreditch Town Hall, and National Theatre Studio.

This production is generously sponsored by Neil and Sarah Brener

First performed at the Traverse theatre on 6 August 2013

COMPANY

Direction	**JOSEPH ALFORD**
Design	**SIMON DAW**
Writing	**MATTHEW HURT**
Light	**ANNA WATSON**
Sound	**GARETH FRY**
Video Design	**SIMON DAW & PADDY MOLLOY**
Illustration	**PADDY MOLLOY**
Choreography	**EVA VILAMITJANA**
Composition	**MARC TEITLER**
Devised and performed by	**LEANDER DEENY**
	DENNIS HERDMAN
	HELENA LYMBERY
	GEORGE POTTS
	CAROLINA VALDÉS
Assistant Direction	**JEMIMA JAMES**
Production Management	**HELEN MUGRIDGE**
Stage Management	**EMMA MCKIE**
Costume Supervision	**CLIO ALPHAS**
Producing	**LUCY MOORE**

COMPANY BIOGRAPHIES

theatre O is a vehicle for co-artistic directors Joseph Alford and Carolina Valdés to create and tour inspirational, devised inter-disciplinary theatre. Their aim is to make work that inspires, moves and challenges both themselves and the audience. They look at the world and try to present it in unexpected and revealing ways, constantly coming back to the dilemmas of ordinary people in extraordinary situations, using humour and playfulness to tell stories that can also be dark and bleak. Previous work includes *3 Dark Tales* (Edinburgh Fringe and Barbican), *Astronaut* (Barbican and International Tour), *The Argument* (Barbican, Mexico, Pittsburgh, Edinburgh Festival and UK tour) and *Delirium* (Barbican, The Abbey Theatre and UK tour), a reinterpretation of Dostoevsky's *The Brothers Karamazov* created with playwright Enda Walsh. theatre O is an Associate Company of Shoreditch Town Hall.

DIRECTION, JOSEPH ALFORD – Joseph is Co-Artistic Director of theatre O. He studied at the École Internationale de Théâtre Jacques Lecoq. His directing work includes *The Man Jesus* (Lyric Belfast); *Delirium* (theatre O) *The Bridge* (Mimbre); *Arsenic and Old Lace* (Derby Playhouse); *Astronaut, The Argument, 3 Dark Tales* (All theatre O); *Bond* (GBP); and *What If...?* (Tohu Bohu). His movement directing work includes *Le Vin Herbé* (Staatsoper Berlin); *Hamlet* (RSC); *Hansel & Gretel, A Woman Killed with Kindness, Beauty and the Beast* and *The Cat in the Hat* (National Theatre); *Play House* (Orange Tree Theatre); *The Trial of Ubu* (Hampstead Theatre); *Idomeneo* (ENO); *Clemency* (ROH2) and *Blackta* (Young Vic).

DESIGN & VIDEO DESIGN, SIMON DAW – Simon designs set, costume and video for theatre, dance and opera as well as creating installation/performance works. Recent projects include: *The Daughter-in-Law* and *Democracy* (Sheffield Crucible and Old Vic); *The Metamorphosis* (Royal Opera House); *As One* (Royal Ballet); *Eventual Progress* (Yekaterinburg Ballet); *Lost Monsters* (Liverpool Everyman); *Dolls* (National Theatre of Scotland); *Fast Labour* (Hampstead Theatre/West Yorkshire Playhouse); *DNA, Baby Girl, The Miracle, The Enchantment* (National Theatre); *Elling* (Bush Theatre and Trafalgar Studios) and *3rd Ring Out*, an interactive simulation of a climate changed future that toured the UK inside two specially adapted shipping containers.

WRITING, MATTHEW HURT – Matthew's play *The Man Jesus* ran at the Lyric Theatre in Belfast earlier this year. His adaptation from the French, *Tuesdays at Tesco's*, won Fringe First at 2011's Edinburgh Festival and his play *Phumzile* was broadcast on BBC Radio 4. Other plays include *Sailing Somewhere* (Johannesburg); *Believe* (Traverse; Finborough and UK Tour; Adelaide; Sweden); *Mortal Ladies Possessed* (Assembly Rooms and UK Tour; New York; Milan) and *Singing! Dancing! Acting!* (Soho Theatre; Athens). Matthew has received bursaries from the Peggy Ramsay Foundation and has been on attachment at the National Theatre Studio. He is currently under commission for the West End.

LIGHT, ANNA WATSON – Theatre credits include: *Bank On It* (Theatre-Rites/Barbican); *A Time to Reap* (Royal Court); *Fireface, Disco Pigs, Sus* (Young Vic); *Salt, Root and Roe* (Donmar); *On the Record, It Felt Empty* (Arcola); *Eden End, In Praise of Love, The Talented Mr Ripley, My Zinc Bed* (Northampton Royal); *Paradise, Salt* (Ruhr Triennale, Germany); *Gambling, This Wide Night* (Soho Theatre); … *Sisters* (Headlong, The Gate). Opera credits include: *Orlando* (Scottish Opera); *Ruddigore* (Opera North); *Critical Mass* (Almeida); *Songs from a Hotel Bedroom, Tongue Tied* (Linbury, ROH); *The Bartered Bride* (Royal College of Music). Dance credits include: *Refugees of a Septic Heart* (The Garage); *Soul Play* (The Place); *View from the Shore* (Clore, ROH, Hall for Cornwall).

SOUND, GARETH FRY – Recent work includes: Soundscape Design for Opening Ceremony of the Olympic Games, *The Master and Margarita* (Complicite); *Othello* (NT); *Hamlet* (RSC); *Trojan Women* (Gate Theatre); *Black Watch* (NTS); *David Bowie Is* (V&A). Also: *Astronaut* (theatre O), *Shun-kin, Endgame, Noise of Time* (Complicite), *Living Costs* (DV8), *Babel* (Stan Won't Dance), *No Idea* (Improbable), *Wild Swans* (Young Vic), *Othello* (Frantic Assembly), *Fahrenheit Twins* (Told By An Idiot), *The Missing, Peter Pan, Be Near Me* (NTS). Awards include: Laurence Olivier Award 2007 for *Waves*; Helpmann Award 2008 and Olivier Award 2009 for *Black Watch*; IRNE Award 2012 for *Wild Swans* in Boston.

ILLUSTRATION & VIDEO DESIGN, PADDY MOLLOY – Paddy Molloy studied Illustration and Animation at Kingston University and Communication Art and Design at the Royal College of Art. Projection design for theatre credits include; *Qudz* (The Yard, 2012), *The Snow Queen* (Polka, 2010), *Origins* (Pentabus, 2009), *A History of Falling Things* (Theatr Clwyd, 2009) and *Delirium* (Theatre O/Barbican Bite/Abbey Theatre, 2008). Print-based illustration clients include; *The Guardian, New York Times* (US), *Globe and Mail* (Canada), *Time Out*, BBC Worldwide, Delta Airlines (US), Hermitage (Russia), HHMI (US) and Random House. He is currently lecturer in Illustration and Animation at Kingston University.

CHOREOGRAPHY, EVA VILAMITJANA – Eva trained as a contemporary dancer and choreographer at Institut del Teatre, Barcelona, and completed her studies at New York, North Caroline, Paris and Wien. She has been awarded by International Tanzwochen (Wien), American Dance Festival (North Carolina), Certamen Coreográfico (Madrid), Premios Ricard Moragas (Barcelona). As a performer she has toured throughout Europe and North and South America with Joe Alegado, Bebeto Cidra, Mar Gómez, Trànsit, Pepe Hevia, Las Malqueridas, Nats Nus Nens, El Liceu (Barcelona), theatre O (UK) and Buissonère (Switzerland). As a choreographer her credits include theatre O: *3 Dark Tales, The Argument, The Astronaut, Delirium* and *The Secret Agent;* Comédie Musical: *Voyage* (France); Entre Tres: *Iaxis Re, Desmai, Quasi Pesa;* LA Petita Malumaluga: *Diuen, La Lluna en un pot* and operas *L'elisir d'amore* (G.Donizetti), *Ruleta, Opera para un fin de siglo*. Eva is co-founder of *La Petita Malumaluga* Dance Company (Barcelona).

COMPOSITION, MARC TEITLER – Theatre includes: *Blood and Gifts* (director Howard Davies/National Theatre); *Twitterdaemmerung* (dir. John Lloyd Davies/Royal Opera House); *Wild Oats* (director Mark Rosenblatt/Bristol Old Vic); *Juliet and Her Romeo* (director Tom Morris/Bristol Old Vic); *ADOT* (director Daniel Junsei/Royal Albert Hall); *The Secret Rapture* (director Guy Retallack/Lyric Theatre.) Musical in development: *The Grinning Man* (director Tom Morris/Bristol Old Vic) co-composed with Tim Phillips; *Baddies* at Unicorn Theatre; *The Death Map* with Bijan Sheibani at National Theatre Studio. Awards/Nominations: *Guardian* 2010 Innovation Award for *Twitterdaemmerung* (Royal Opera House) composed with Helen Porter; 2013 Best Music for Animated Film Nominee at Berlin Independent Film Festival; 2005 VW Film Score Award Nominee.

DEVISOR & PERFORMER (STEVIE & VLADIMIR), LEANDER DEENY – Theatre Includes *The Misanthrope* (Liverpool Playhouse); *Deadkidsongs* (Ustinov Studio, Bath); *Bugsy Malone* and *Brief Encounter* (Secret Cinema); *The Man* by James Graham and *The Representative* (Finborough); *Dr Faustus* (Watford Palace Theatre); *Victory* by Howard Barker (Arcola); *Corporate Rock* by John Donnelly (Latitude); *The Merchant of Venice, Holding Fire!* (Shakespeare's Globe) and *The Seduction of Almighty God* by Howard Barker (Riverside Studios). Television includes *Skins, Merlin,* and guest regular George Binns on *Holby City*. Film includes *Captain America* and *Atonement*. His first children's book, *Hazel's Phantasmagoria,* is published by Quercus.

DEVISOR & PERFORMER (OSSIPON & INSPECTOR HEAT), DENNIS HERDMAN – Recent theatre includes: *Around the World in 80 Days, Bleak House* (New Vic, Stoke); *A Midsummer Night's Dream* (Told By An Idiot, Helsinki); *Stones In His Pockets, Closer, Not A Game For Boys, Kiss of the Spiderwoman, Anorak of Fire* (Keswick); *The Suicide, An Inspector Calls* (Clwyd Theatr Cymru); *Carnival Messiah* (Cherub Theatre); *The Mysteries* (Belgrade Theatre, Coventry); *Romeo and Juliet, Great Expectations* (Shifting Sands); He has also worked at Manchester Library, Northampton Royal, Southwark Playhouse, Chester Gateway; and with Cartoon de Salvo, Penny Dreadful, Walk The Plank, Big Telly, Third Party, and played Dame and much else in pantomime at Theatre Royal, Bury St Edmunds.

DEVISOR & PERFORMER (MOTHER & THE PROFESSOR), HELENA LYMBERY – Theatre work includes: *This House, The Cat in the Hat, ..some trace of her, Women of Troy, Attempts on Her Life, Iphigenia at Aulis, His Dark Materials* (National Theatre); *Coasting* (Bristol Old Vic); *Roughcuts – God Bless the Child* (Royal Court); *Yerma* (West Yorkshire Playhouse); *Blackpool* (Theatre503); *Light Shining in Buckinghamshire* (Arcola); *Al Gran Sole Carico d'Amore* (Salzburg Festival, Berlin Staatsoper); *After Dido* (ENO/Young Vic); *Sleeping Beauty* (Barbican, NY, Young Vic); *Watership Down* (Lyric Hammersmith); *Mammals* (Bush Theatre); *Faith, Hope & Charity, The Woman Who Swallowed a Pin* (Southwark Playhouse); *The Asylum Project* (Riverside Studios); *Strike Gently Away from Body, The Art of Random Whistling* (Young Vic). TV includes: *Father Brown, Oliver Twist,* Alastair McGowan's *Big Impression*.

DEVISOR & PERFORMER (ADOLF VERLOC), GEORGE POTTS – Theatre credits: *The Misanthrope* (Liverpool Playhouse/ETT); *Angus, Thongs and Even More Snogging* (West Yorkshire Playhouse); *Edmond* (Wilton's Music Hall) *Arcadia* (Duke of York's Theatre); *All My Sons* (Liverpool Playhouse); *Murderer* (Menier Chocolate Factory); *The Art Of Success* (Arcola). TV credits include: *Big Bad World, Nixon's The One, Peep Show, In With The Flynns, Parade's End, The Cricklewood Greats, Lip Service, Hotel Babylon, Little Dorrit, Mutual Friends, Much Ado About Nothing, Messiah, North and South.* Film credits: *Nativity! The Second Coming, Papadopoulos and Sons, Harry Potter and the Deathly Hallows, Burke and Hare, Bel Ami, Dorian Gray.*

DEVSIOR & PERFORMER (WINNIE VERLOC), CAROLINA VALDÉS – Carolina is Co-Artistic Director of theatre O. She studied at the École Internationale de Théâtre Jacques Lecoq and at Col.legi de Teatre in Barcelona. She has performed in *Julius Caesar* (Donmar Warehouse); *The 13 Midnight Challenges of Angelus Diablo* (RSC); *Delirium* (theatre O); *Casanova* (Told by an Idiot); *Lyndie's Got A Gun* (Enda Walsh); *The Barber of Seville* and *Carmen* (Opera 21); *Astronaut, The Argument, 3 Dark Tales* (theatre O) and *Bond* (GBP). Her television credits include *Call the Midwife* (BBC1) and for film *A Little Chaos* (Alan Rickman). Her directing work includes *The Garden* and *Reykjavik* (Shams) and as a Movement Director, *The Resistible Rise of Arturo Ui* (Liverpool Playhouse) and *Absurdia* (Donmar Warehouse).

ASSISTANT DIRECTION, JEMIMA JAMES – Jemima trained at The Central School of Speech and Drama, specialising in Collaborative and Devised Theatre. She has worked as an actor and theatre maker with Complicite, theatre O and Quiconque, and is the Artistic Director of newly formed company, Past The Hour.

PRODUCTION MANAGEMENT, HELEN MUGRIDGE – Helen is an experienced stage and production manager. Her previous credits include: *The Victorian in the Wall*, Will Adamsdale and Fuel (Royal Court and National Tour), *Rockpool,* Inspector Sands (Schools Tour), *Monkey Bars,* Chris Goode & Co (Edinburgh Fringe Festival, Tour and Unicorn), *Mass Observation,* Inspector Sands (Almeida), *Cooking Ghosts,* Beady Eye (South East Tour and Camden People's Theatre), *BYO,* Thickskin (Research and development), *2401 Objects,* Analogue (National Theatre and European development, Edinburgh 2011 and National and European Tour), *Total Football,* Ridiculusmus (Barbican Pit, Belfast Festival and Autumn 2012 tour), *Beachy Head,* Analogue (National and European Tour).

STAGE MANAGEMENT, EMMA MCKIE – Stage Management theatre credits include: *Much Ado About Nothing*, *Merchant of Venice* and *The Homecoming* (RSC); *Kursk* (Fuel/Sydney Opera House); *The Crucible* and *Into the Woods* (Regent's Park Open Air Theatre); *Hansel and Gretel* (Catherine Wheels Theatre Company/Barbican and New Victory Theater, Broadway); *Molly Sweeney* and *Fabrication* (The Print Room); *The Snowman* (Birmingham Rep/West End); *Everything Must Go*, *Behud* and *Invasion!* (Soho Theatre); *Sense* and *Boiling Frogs* (Southwark Playhouse), *Delirium* (theatre O/Abbey Theatre, Dublin and Barbican Pit); *Switzerland* and *I Caught Crabs in Walberswick* (Hightide Festival).

COSTUME SUPERVISION, CLIO ALPHAS – Clio Alphas graduated from London College of Fashion in 2010, with an MA in Costume for Performance. Ever since, she has been working as a costume designer and maker in London and Cyprus.

PRODUCING, LUCY MOORE – Lucy is an Independent Producer working with a number of companies including theatre O (*The Secret Agent*), Cartoon de Salvo (*Made Up* and *The Irish Giant*), and Inspector Sands (*Mass Observation*, *Rock Pool* and *A High Street Odyssey*). Interested in the role and sustainability of independent producers, Lucy along with independent producers Emily Coleman and Ruth Dudman, is currently exploring 'SOUPing' as an action and model of working which enables independent producers to advocate for, and better support, each other. Lucy has worked in various organisations including China Plate, ArtsAgenda, Battersea Arts Centre and the Arts Council England.

SUPPORTERS
Dr Neil and Sarah Brener
Mr and Mrs R Carr
Mr and Mrs J Keenan

THANKS & ACKNOWLEDGEMENTS

Laszlo and Wilhelmina Valdés-Alford	David Micklem
Jessica Alford	Katie Mitchell
Richard & Penny Alford	Hannah Montague
Dominic Burdess	Purni Morell
Helen Burgun	Natasha Nixon
Polly Cetin	Edward and Lizzie Parry
Peter Challis	George Ramsay
Rachel Daniels	The Rockmounters
Nelson Fernandez	Oliver Senton
Gus Casely-Hayford	Daniel Smith
Eddie Keogh	Lizzie Wingham
Roula Konzotis	Griselda Yorke
Ellen Mcdougall	Simon Zimmerman

Young Vic

'The Young Vic is one of our great producing theatres.'
The Independent

'A powerhouse of endearing delight and shattering drama.'
Daily Telegraph

'The sexiest theatre in London.'
Time Out

Our shows
We present the widest variety of classics, new plays, forgotten works and music theatre. We tour and co-produce extensively within the UK and internationally.

Our artists
Our shows are created by some of the world's great theatre people alongside the most adventurous of the younger generation. This fusion makes the Young Vic one of the most exciting theatres in the world.

Our audience
...is famously the youngest and most diverse in London. We encourage those who don't think theatre is 'for them' to make it part of their lives. We give 10% of our tickets to schools and neighbours irrespective of box office demand, and keep prices low.

Our partners near at hand
Each year we engage with 10,000 local people – individuals and groups of all kinds including schools and colleges – by exploring theatre on and off stage. From time to time we invite our neighbours to appear on our stage alongside professionals.

Our partners further away
By co-producing with leading theatre, opera, and dance companies from around the world we create shows neither partner could achieve alone.

David Lan, Artistic Director
Lucy Woollatt, Executive Director

The Young Vic is a company limited by guarantee, registered in England No. 1188209.
VAT registration No. 236 673 348
The Young Vic (registered charity number 268876)
receives public funding from:

Lead sponsor of the Young Vic's funded ticket scheme

GET MORE FROM THE YOUNG VIC ONLINE

📘 **/youngvictheatre**
📧 **@youngvictheatre**
▶️ **/youngviclondon**
📶 **youngviclondon.wordpress.com**
Sign up to receive email updates at **youngvic.org/register**

warwick arts centre

Based in Coventry in the West Midlands and sitting on the campus of the University of Warwick, Warwick Arts Centre is one of the most significant presenters and co-producers of contemporary performance and visual arts in the UK.

A multi-venue space, Warwick Arts Centre comprises of a 1,500 seat concert hall, a 550 seat theatre, in addition to two studio spaces, a cinema, and the renowned Mead Gallery. In 2011/2012, Warwick Arts Centre hosted 774 film screenings, 516 live performances and welcomed 16,500 visitors to the Mead gallery.

Featuring a wide and varied programme including theatre, classical and contemporary music, dance, literature, comedy, family events and visual art, Warwick Arts Centre's work is avowedly international in scope and dimension.

Warwick Arts Centre is dedicated to co-producing, commissioning and supporting the early stage development of new work. Triggered@ Warwick is Warwick Arts Centre's commissioning and artist development programme supporting selected artists with time to develop creative ideas, a physical space to work in and the opportunity to receive feedback from a live audience. Past works that were "triggered" at Warwick Arts Centre include Caroline Horton's *Mess*, Mark Murphy's *Take a Deep Breath* and Glen Neath and David Rosenberg's *Ring*.

Warwick Arts Centre also seeks new avenues for artistic inspiration, facilitating connections that lead to new work. The This_is_Tomorrow project seeks to make use of our close ties with the University of Warwick, to generate new artistic ideas through artist and academic collaborations. The aim is to explore and illuminate contemporary thinking and research about the human condition and key issues that face humanity and society across a range of science, social science and humanities subjects.

Warwick Arts Centre remains at the forefront of West Midlands cultural life, growing new audiences and promoting new ideas across a wide range of art forms.

SHOREDITCH
TOWN HALL
OLD STREET, LONDON, EC1

Shoreditch Town Hall is an arts and cultural centre sitting at the heart of one of the most vibrant areas of London. A landmark building, it was for over 100 years one of the grandest vestry halls in the capital and is probably the largest existing space of its kind to be reinvented as an arts venue in a generation. Comprising of seventy individual rooms and spaces – from the magnificent Victorian grandeur of the Assembly Hall and Council Chambers to the warren of untouched, atmospheric basement rooms – the Town Hall is home to a growing live performance programme as well as being an increasingly vital base for the development of new work and emerging talent from a wide range of theatre, dance and visual artists.

theatre O is an Associate Company of Shoreditch Town Hall. Other Associates are Analogue, Oscar Mike and simple8, with Affiliates being Clod Ensemble and LIFT.

National Theatre Studio

The National Theatre Studio is the NT's laboratory: a place for experimentation and development for writers, directors, actors, designers and theatre-makers of all kinds, free from the pressure of public performance. It provides the resources, circumstances and environment to support both emerging and established theatre-makers of outstanding talent, and contributes to the National's ongoing search for and training of new artists.

Since its foundation in 1984, the Studio has played a vital role in promoting the health and renewal of theatre at large, developing work for the National's repertoire and throughout British theatre. In recent years, productions as diverse as *His Dark Materials, Stuff Happens, Waves, War Horse* and *London Road* have all been workshopped and developed there. The Studio building – situated in Waterloo, near the National Theatre – re-opened in 2007 after a £6 million redevelopment. It also houses the National Theatre Archive (open to the public by appointment), and a space for NT Learning. Its two large workshop studios, five resident artists' rooms, range of meeting rooms, dressing rooms and offices make it a unique resource in the theatrical world.

In addition to play readings and workshops, the Studio hosts artists on attachment; supports and develops directors; and has a number of affiliate companies.

THE SECRET AGENT

theatre O and Matthew Hurt

THE SECRET AGENT

OBERON BOOKS
LONDON

WWW.OBERONBOOKS.COM

First published in 2013 by Oberon Books Ltd
521 Caledonian Road, London N7 9RH
Tel: +44 (0) 20 7607 3637 / Fax: +44 (0) 20 7607 3629
e-mail: info@oberonbooks.com
www.oberonbooks.com

A catalogue record for this book is available from the British
Library.

PB ISBN: 978-1-78319-041-6
E ISBN: 978-1-78319-540-4

Cover design and illustrations © Paddy Molloy

Printed, bound and converted
by CPI Group (UK) Ltd, Croydon, CR0 4YY.

Visit www.oberonbooks.com to read more about all our books
and to buy them. You will also find features, author interviews and
news of any author events, and you can sign up for e-newsletters
so that you're always first to hear about our new releases.

Introduction

Joseph Conrad dedicated *The Secret Agent* to his friend and mentor H.G. Wells – Conrad describing Wells lovingly as 'an historian of the ages to come'. Though short-lived, it was an important relationship for Conrad. In his admiration for the work of Wells are important clues about his own writing aspirations. Anyone who has read *The Secret Agent* will know it to be as prophetic as anything that Wells wrote. Whilst H.G. Wells hypothesized how science might rescue humanity, Conrad captured something of the future of our inner landscapes, of how basic failings in the human condition would impact upon what we might become.

Conrad knew about the human condition, in his twenty years as a merchant marine he had travelled widely and seen first-hand the best and worst of many of the things that his peers described in their fiction. Even the extraordinary *Secret Agent* is in part excavated from Conrad's own memories. His father, a Polish patriot and anarchist sympathizer was arrested and sent with his family to a remote region of Russia. It was tragedy that unfolded in agonizing slow motion, as first his mother and then his father succumbed to fatal tuberculosis, and young Joseph learned how state-sponsored paranoia could impact upon ordinary people.

Conrad began his writing career in the late nineteenth century as the gearing and grease between the great cogs of Western European society had begun to fail, just as he had seen in the Eastern Europe of his childhood. Class, Empire, sexual politics, religion, race: the substantive cultural pillars that had supported the most productive period in modern European history began to clash one upon another. By the end of the century, it was no longer a question of whether change was coming, but of its impending scope and scale, of who would be the victors, and who would buckle and be broken beneath what threatened.

Conrad settled in London, from where he watched over years as the tide of political instability swept across Europe. Then in early 1894 it found its way back to his door. Conrad read with amused horror how Martial Bourdin, a young, emaciated

anarchist had blown himself to pieces just beneath Greenwich Observatory, leaving nothing but questions for the police. It appeared a completely senseless act. As Conrad observed, *'the outer wall of the Observatory, it did not show as much as the faintest crack.'*

In the carnage Conrad had found his Secret Agent – the story of a family unraveling in the wake of a bomb – of how loss and grief would prove as incendiary as the dynamite. To write the story he mined his own losses without self-pity, often blurring the line between pathos and comic, between tragedy and satire. He saw loss through a variety of filters: as a mechanism to interrogate political naiveté, to explore the corruption of innocence and the magnetism of evil. All themes well-covered by his contemporaries, but Conrad forces us to dive deeper into darker waters, giving a platform to the victims, and real voices to the evil – told their difficult and tragic stories without moralizing or trying to lessen the profundity of their plight with the satisfying endings of Shaw and Kipling or the bucolic romance of Hardy. Each character is beautifully crafted but equally flawed and damaged. There is the echo of the asylum-scream in every passage of humour, but it is even more dangerously funny because of it.

Since 9/11 *The Secret Agent* has established a place as part of the cultural curriculum for a new generation who have celebrated its eerie prescience, its broken counter-heroic characters, its strong amoral undertow and a beautiful narrative arc that ruptures and disintegrates in the wake of the bomb. It has proven as Conrad hoped, a timeless tale – an ever-shocking story.

And theatre O have turned *The Secret Agent* into something visually astonishing, something wonderful. They have brought their unrivalled skills in physical theatre to telling Conrad's intimate epic with an exquisite finesse. The process the company deploys is inherently risky – they begin rehearsals with minimal scripts and discover the play together. Each actor finding their character, developing their back-story as simultaneously select scenes, choreography, sets are fashioned around and through their shared discoveries. The best results of these improvised scenarios are tightened and scripted for inclusion in the finished productions. It is a process that is

driven by collaboration, as the experimental work finds its place alongside the crafted pre-scripted scenes. The process is difficult and risky, but its dangers are mitigated by the skill of those involved and trust that they share in the team and the process.

The Secret Agent might be considered a difficult story: loss is heaped upon loss – loss of old century values, loss of ideology, loss of love and ultimately loss of hope. It is an archaeology of Conrad's pain, of our contemporary concerns, but within that loss is humour and humanity. Years after his relationship with H.G. Wells had broken down, Conrad wrote of his old friend, *'you don't care for humanity, but think they are to be improved. I love humanity, but know that they are not!'*

Gus Casely-Hayford
2013

A Note on the Text

The text of this play is only one element of the whole.
Movement, music and animation also form integral parts of
the storytelling. Balancing these various elements has required
almost constant reappraisal. As a consequence, the text
printed in this script – while hopefully very close to the words
used in the final production – may not be the exact text that
is performed. In keeping with theatre O's spirit of playfulness,
this script might be thought of as a single snapshot at a
particular moment in time of an ever-evolving animal.

1. THE CABINET OF DESIRES, OU LE CABINET DES DESIRES

MOTHER *appears in the Cabinet of Desires.*

MOTHER: A woman who hated surprise
 Went around with completely shut eyes
 She got in a muddle
 And slipped in a puddle
 And now six feet under she lies

MOTHER *comes out of the Cabinet of Desires.*

 There once was a lass from Belgravia
 With very unusual behaviour
 For her bedside light
 She used dynamite
 And now all her hair is much wavier

VERLOC *appears in the Cabinet of Desires.*

VERLOC: Ladies and gentlemen: welcome to the Cabinet
 of Desires – *Le Cabinet des Desires.* What you
 are about to see is: yourself. You. Your secret
 desires. So secret, in fact, you may not even
 know that they exist.

 Now, to help me with this astonishing act of self-
 deception, my devastating assistant and also my
 wife: the Damsel of Desire – *la Femme du Cabinet*
 – the Lady of the Cabinet!

WINNIE *appears in the Cabinet of Desires.*

 Ladies and gentlemen, no matter which way
 you look at it, everything needs to change. The
 conditions of the present – social, economic,
 material, intellectual – must change.

 Winnie.

WINNIE: ***(Going up to an audience member.)*** *Good evening,
 sir. Are you into sexual gadgets? How about this?*

> *Ladies' underwear? Would you like to touch it?*
> *Careful, it's very fragile. Easily ripped.*

VERLOC: Thank you, Winnie.

WINNIE *disappears into the Cabinet of Desires.*

> The powers that be, our oppressors, use the
> idea that you and I are just lone and feeble
> individuals among so many billion other lone
> and feeble individuals to paralyse us. They use
> the idea that we are the smallest of cogs – easily
> worn out, easily replaced – in the eternal clock
> to unwind our resilience; to stop us. Because,
> ladies and gentlemen, what is a clock without a
> spring?
>
> Sweetheart.

WINNIE *appears in the Cabinet of Desires, blindfolded and bound.*

WINNIE: *(To another audience member.)* *Good evening,*
 madam. Do the helpless turn you on? I'm helpless and
 I'm hungry – would you feed me a biscuit?

VERLOC: That's enough, darling.

WINNIE *disappears into the Cabinet of Desires.*

> A clock without a spring, ladies and gentlemen,
> is nothing but an inert chaos of cogs. Because
> without the spring, no motion; the hand traces
> no circles. And without circles: no time. Nothing
> happens. And that's exactly what they want. To
> stop us from advancing. They want this because
> the ultimate weapon in the hand of any man,
> ladies and gentlemen, is progress.
>
> Winnie.

WINNIE appears in the Cabinet of Desires, dressed as Dracula.

WINNIE: *(To another audience member.)* *Good evening, sir. Do you like Dracula? Would you like to be slapped...? ...Would like to slap me? Do you want me to sit on you? Would you like me to bite you? Would you like me to suck the blood out of you?*

VERLOC: Darling!

WINNIE disappears into the Cabinet of Desires.

The act of destruction is a creative one. I speak to you not as a fool, but as a man. I'll show you – we'll show you – the future. And the past. And the present. Because what is the present if not tomorrow's past?

So, ladies and gentlemen – welcome. Welcome to your secret selves. Look into the Cabinet of Desires – *Le Cabinet des Desires* – a place of mystery and enchantment – *bang!* – of wild craving and unbridled yearning – *boom!* – and see – see whatever it is you want.

2. MEMENTO MORI

A *memento mori* – a death portrait – of *VERLOC*, *WINNIE*, *STEVIE*, *MOTHER* and *OSSIPON*, explodes in slow motion.

3. THE HOUSE OF VERLOC – BREAKFAST

VERLOC, WINNIE, STEVIE and MOTHER in the parlour.

WINNIE: Stevie.

MOTHER: Gently, Stevie, gently.

STEVIE: S – sorry.

MOTHER: Don't you know Mr Verloc needs peace and quiet to relax in the morning? 'Specially this morning.

VERLOC: Where've I put my *Times*?

STEVIE *finds the newspaper and hands it to Mr VERLOC.*

STEVIE: S – sorry.

MOTHER: Winnie – Winnie – Winnie – rug's not straight.

Would you like a coffee, Mr Verloc?

VERLOC: Have I got time?

MOTHER: Coffee helps a man think straight. Not that you need any help thinking, Mr Verloc. Coffee for your husband, Winnie, and I'll have one 'an all while you're at it.

WINNIE: Be patient, Mother. It's coming.

MOTHER: Fancy no coffee before such a big important meeting.

STEVIE: B – big – meeting.

VERLOC: You'll make me nervous if you carry on like this.

WINNIE: Yes. You should stop.

MOTHER: Mr Verloc? Nervous? Never.

Sausage and eggs for breakfast, Mr Verloc. Keep you fighting fit.

Winnie – Winnie – Winnie – no mustard, Winnie? You can't expect a man of Mr Verloc's refined sensibility to swallow a sausage without any mustard.

She's forgotten the little spoon that goes with it.

STEVIE gets a knife; WINNIE takes it from him and puts the spoon on the table.

STEVIE: S – sorry.

MOTHER: I mean, standards slip and what are you left with? Difference between us and the savages, isn't it?

STEVIE: S – savages.

MOTHER: Spoon for the mustard.

Winnie – Winnie – Winnie!

What Mr Verloc needs right now's peace and quiet so he can gather himself for his day ahead.

Nice piece of cod for dinner tonight, Mr Verloc, cooked in our fish kettle. … Fish kettles always make me think of your father, Winnie. We're married, he said, have this – and handed me a fish kettle. Happiest day of my –

VERLOC: Is this clock fast?

WINNIE: Stevie. Mr Verloc's coat.

MOTHER: When you were in France, Mr Verloc, growing up, growing up as a little French boy – when your mother cooked for you – was the food French?

VERLOC: Completely.

STEVIE nearly knocks over the clock.

STEVIE: S – sorry.

MOTHER: Never any peace or quiet for the poor man.

Oh, Winnie! Oh, Winnie – doesn't he look –

Don't you – *sacrébleu*, Mr Verloc – don't you look
– I hope you don't mind me saying – but don't
you look handsome?

VERLOC: Oh stop it, Mother.

MOTHER: A man of standing. I'm honoured to live under
the same roof. A man of standing going out
in the world to do Lord alone knows what
wonderful things.

4. THE WORLD ON FIRE

VERLOC: ***(Sings 'I Don't Want to Set the World on Fire'.)***
*I don't want to set the world on fire, I just want to
start a flame in your heart…*

5. VLADIMIR

VERLOC and VLADIMIR in the Embassy.

VLADIMIR: How may I be of assistance?

VERLOC: I'm here for my…appointment.

VLADIMIR: Your appointment's at what time?

VERLOC: Eleven o'clock.

VLADIMIR: With whom?

VERLOC: Mr… Is it safe to speak…freely here?

VLADIMIR: This is an Embassy.

VERLOC: My appointment is with Mr Vladimir.

VLADIMIR: Not so loud.

VERLOC: But –

VLADIMIR: Who did you say you are again?

VERLOC: I didn't.

VLADIMIR: Secretive.

VERLOC: Verloc. Adolf Verloc.

VLADIMIR: Excellent. … Let me just find – Vladimir –
 eleven o'clock – no: you can't possibly have an
 appointment then.

VERLOC: But his letter said eleven o'clock.

VLADIMIR: Must have been a typo. Probably meant to say
 seven. Or nine. Or possibly twelve. My advice is
 that you go away and come back again.

VERLOC: Tomorrow?

VLADIMIR: Your appointment is today. You need to go away
 and come back today. As soon as possible. Shall
 we see how that feels?

VERLOC: Alright…

VLADIMIR: Go on then. Go.

VERLOC exits.

 Are you ready to meet Mr Vladimir?

VERLOC: *(Off.)* I was ready before.

VLADIMIR: Come back in again now.

VERLOC enters.

 You're late.

VERLOC: Pardon?

VLADIMIR: Our meeting was for eleven sharp.

VERLOC: But I'm meeting with – I'm meant to be meeting
 with Mr Vladimir.

VLADIMIR: Vla-*di*-mir. The stress is on the second syllable of
 my name.

VERLOC: But we just –

VLADIMIR: The stress is on the second syllable.

VERLOC: Why didn't you –

VLADIMIR: Stress.

VERLOC: I thought Mr Vladimir had a meeting now.

VLADIMIR: Second syllable.

VERLOC: What?

VLADIMIR: You're not in the peak of condition, are you? In fact: voluptuous. Telling. The state of your body reflects the state of your mind. And anarchists should not have flabby minds. Should they? We'll need one two three four five six – six chairs.

VERLOC: For what?

VLADIMIR: The meeting. Six chairs. Go. Go. Six.

 And a table.

VERLOC starts getting chairs.

 Now tell me who you are.

VERLOC: I've told you, I'm Mr –

VLADIMIR: Not your name, Mr Verloc. Not your name out loud. Not here. Not here in the Russian Embassy, Mr Adolf Verloc. Mr Adolf Verloc of Brett Street. Your cipher.

VERLOC: It's… I'm a triangle.

VLADIMIR: It's called Delta, you cunt, and it's not a fucking triangle it's a Greek symbol. One, two, three, four – I'm counting four chairs and I'm fairly certain in fact I know I said six. Six minus four is?

VERLOC: Two.

VLADIMIR: Explain to me what it is that you do.

 Chairs! What kind of Secret Agent Twinkly
 Triangle can't arrange furniture and speak at the
 same time?

VERLOC: I…how'd you mean? You know what I do.

VLADIMIR: I know you're on our payroll.

VERLOC: Yes, because I –

VLADIMIR: Pomade.

VERLOC: Pardon?

VLADIMIR: It's there – in my handbag – no, not there – left,
 right, up a bit – yes.

 Can we go for Centurion helmet? Ridge, not
 Imperial Gallic.

 You were saying.

VERLOC: You want me to –

VLADIMIR: Up and swooshy at the front.

 Your reason for being on our payroll.

VERLOC: I…you know I send reports, on –

VLADIMIR: The more the better. It's blustery today.

VERLOC commences styling VLADIMIR's hair.

VERLOC: I report on – I've infiltrated a circle of anarchists
 and I report to you – as you know – on their
 activities.

VLADIMIR: On their what?

VERLOC: Activities.

VLADIMIR: Don't interrupt me.

VERLOC: You asked me a –

VLADIMIR: But they do nothing. Just like you do nothing.

VERLOC: I don't do nothing. Look at my records you'll see three months ago I provided information –

VLADIMIR: Swooshier.

VERLOC: – on a planned assassination attempt –

VLADIMIR: Bombs tossed into crowds. Arbitrary as hot oil spitting from a frying pan. But we don't need arbitrary, do we?

VERLOC: I don't know.

VLADIMIR: Stop interrupting me.

: Do we?

Hello? Are you deaf as well as stupid, pig man? I've asked you a question.

VERLOC: I don't… I think… You've lost me.

VLADIMIR: I don't I think you've lost me. I don't I think you've lost me. I don't I think –

Now do your hair. Do your hair.

It's very stressful, actually, talking to you. Do you mind me saying?

And it hurts, you know. Hurt. Right here. And here. And…here. I thought we were friends – what have I done to hurt you? – you pretend friendship and pledge to protect me, protect us – that's what your job is – but instead you do – do you? – you do – nothing.

I thought you said the meeting started at eleven.

VERLOC: You said that.

VLADIMIR: So where are the guests?

VERLOC: I don't…

VLADIMIR: Get those two.

VERLOC approaches two members of the audience.

No, not those two. Those two.

VERLOC fetches two dolls.

Well. Aren't you going to introduce me?

VERLOC: They're…dolls.

VLADIMIR: One is a doll. The other's more of a dummy. Both should have names. Name them.

VERLOC: This one's… Doll. Doll. And Dummy.

VLADIMIR: I'm going to give them first names. Mary-Elizabeth Doll and Aloysius Dummy. Aloysius is going to be portraying the role of the world-famous anarchist Bakunin. Now I want you to tell Bakunin what's coming. Why it is you and your pals gather like clucking hens twice a week to talk about – what's coming?

VERLOC: I don't know what's –

VLADIMIR: *(As Bakunin.) Vot's coming?*

VERLOC: Well: the future –

VLADIMIR: *(As Bakunin.) I'm so alone.*

VERLOC: – has no future.

VLADIMIR: *(As Bakunin.) So cold.*

It was funny twice but it'll be funnier the third time.

VERLOC: The era –

VLADIMIR: *(As Bakunin.) Cold and alone!*

It was the funniest time!

What's coming?

VERLOC: I don't –

VLADIMIR: How in the name of giddy fuck can you call yourself an anarchist and not know what's coming? Anarchists want – WHAT?

VERLOC: Revolution!

… Is that what's coming?

VLADIMIR mournfully sings the Kaddish.

VLADIMIR: …Yes. Revolution.

Do you dream?

VERLOC: No.

VLADIMIR: I do, too.

: And they're less like dreams, my dreams: more like nightmares. And I'm not sleeping while I have them. In fact, they're more like visions.

May I share one with you?

VERLOC: … Alright.

VLADIMIR: All right? No, it's not alright. Not at all. Public squares, bristling with rabid mobs. Looters and opportunists. Scum of society, anyone with a grudge, rapists – they take my daughter –

Mary-Elizabeth Doll will portray the role of Florence, my daughter. In twenty years' time she'll be ten. I have children late.

A gang frogmarch Florence and me, hoods over our heads, to a dusty patch of no-man's-land; where they make me watch as my innocent daughter is…repeatedly…violently…by each of them. Before they push us up against a wall and –

***VLADIMIR** mimes shooting the doll through the head.*

And do you know who this gang is that does this to us?

VERLOC: No.

VLADIMIR: **(Pointing at the dummy.)** It's him. Him and the comrades – the friends – that you – you! – Agent **(Draws a triangle in the air.)** who is taking a weekly salary from me for spying on them but to absolutely no effect – it's them.

We need the other guests.

No. I can't trust you to do it.

***VLADIMIR** brings four audience members on to the stage and seats them.*

Sir. Madam. You. Yes – you. And you. Over here, please. Yes. Thank you. Nothing to be worried about. It's all about him. …There are biscuits. … Everyone alright? … Comfy?

(To VERLOC.) Now, Adolf. Meeting agenda item number one: Verloc to explain why it is they need to be scared.

VERLOC: To stop… About…your daughter being shot in the head?

VLADIMIR: They're not scared, Adolf.

Explain it in terms that will frighten them.

***VERLOC** picks up Mary-Elizabeth Doll.*

Good.

VERLOC: They need to be scared to stop this from happening?

VERLOC half-heartedly shows Florence being killed.

VLADIMIR: Who's scared? Hands up?

No one.

Have another go.

VERLOC makes a more committed effort.

VLADIMIR: Scared? Any one? Hands up?

Make her talk.

…What does she say?

VERLOC: *Daddy, I'm really frightened. Please don't let the soldiers come and…and…shoot me.*

VLADIMIR: At the very end I tell her that the soldiers aren't going to shoot her. She was reassured. I said 'Don't worry, they're not real guns. The soldiers are just playing dress up.' What did she say when I told her that?

VERLOC: *That's…really great?*

VLADIMIR: What did I say – after – when she was shot?

You're right. I said nothing.

Now: was anybody scared? I mean, not play-play scared. Really scared. Bed-drenching terror. Anyone? At the image of a little girl being shot?

No.

I pay you every week, and they are not scared. In fact, they don't care. Do you understand?

No.

They need to be scared. Otherwise they'll continue to welcome dissidents and terrorists and preachers of hate and refuse to extradite suspected criminals and call it providing asylum

in the name of freedom of expression and civil liberties and human rights.

So what are you going to do?

VERLOC: I could…spread rumours about…poison in the city's water supply.

VLADIMIR: – waits for no man.

VERLOC: How about…a church? Or arson attack on a mosque?

VLADIMIR: Old Father – .

VERLOC: A commuter train?

VLADIMIR: – is relative.

 There is a – and a place for everything.

 It happened in no – .

VERLOC: I don't understand.

VLADIMIR: Why was six afraid of seven?

VERLOC: Because seven ate nine?

VLADIMIR: Seven eight nine.

 Ten.

 Eleven.

 You see?

VERLOC: Numbers.

VLADIMIR: Twelve.

VERLOC: Thirteen.

VLADIMIR: Fourteen.

VERLOC: Fifteen – this could go on forever.

VLADIMIR: Exactly! It could. But what if it didn't? What if we could stop the sequence? What if we could stop one thing – one moment – leading to another?

VERLOC: You can't stop time.

VLADIMIR: No, but you could bomb it.

VERLOC: … Excellent. Now I see! Amusing: we could blow up Big Ben.

VLADIMIR: Too high. Can you think of another clock?

VERLOC: There's a clock in Waterloo.

VLADIMIR: Not very central. We need to get to the heart.

VERLOC: Of time?

VLADIMIR: Excellent idea. Where is it?

VERLOC: Time doesn't have a heart.

VLADIMIR: Rhymes with heart: start. Where does time start?

VERLOC: Twelve o'clock?

VLADIMIR: Midnight is not a place.

VERLOC: But time doesn't actually start at a place. I mean, they measure it from – you know.

VLADIMIR: No.

VERLOC: From –

VLADIMIR: Where?

VERLOC: Well, the first meridian.

VLADIMIR starts to applaud, and encourages the audience members seated on the stage to do so too.

VLADIMIR: Bravo!

VERLOC: You can't bomb an imaginary line.

VLADIMIR: Is the Observatory in Greenwich imaginary?

VERLOC: No…

VLADIMIR: You see: now they're scared.

VERLOC: They don't look scared to me.

VLADIMIR: They're covering their fear with smiles. / They will be.

And you know why? Because to make people feel anything at all the act needs to be incomprehensible; mad, in fact. Madness alone is truly terrifying. You can't threaten it; you can't reason with it; you can't bribe it.

Can you?

Now take them away. *(Shutting his eyes.)* And tell me when they're gone.

VERLOC returns the audience members to their seats.

VERLOC: Gone.

VLADIMIR: Everyone on this Septic Isle – the whole world! – has heard of the Observatory at Greenwich. Yet no one will be able to explain it. Who'd suspect a member of a terrorist cell had a personal grievance against time?

VERLOC: But – Mr Vladimir, an operation like this – unprecedented –

VLADIMIR: Haven't you got the entire underground network of wannabe terrorists to help you out? Tom Ossipon, for example: at least he's physically fit. Oh yes, I know all their names and medical conditions – if you think for one minute you're our only inside man, think again.

VERLOC: But it'll cost money.

| VLADIMIR: | That cock won't fight. You'll still get your pay every week, but if nothing happens very soon that tap will be turned off. Forever. |

The first meridian.

I give you two weeks.

And Verloc.

| VERLOC: | Yes? |

| VLADIMIR: | Don't let me down. |

6. THE HOUSE OF VERLOC – DINNER

VERLOC, WINNIE, STEVIE and MOTHER in the parlour.

| WINNIE: | Stevie. |

| MOTHER: | Gently, Stevie, gently. |

| STEVIE: | S – sorry. |

| MOTHER: | Don't you know Mr Verloc needs peace and quiet to relax in the evening? 'Specially this evening. |

| STEVIE: | S – sorry. |

| MOTHER: | Winnie – Winnie – Winnie – rug's not straight. |

Would you like some claret, Mr Verloc?

The family looks to VERLOC for a response – they get none.

| MOTHER: | Claret helps a man think straight. Not that you need any help thinking, Mr Verloc. Claret for your husband, Winnie, and I'll have one 'an all while you're at it. |

| WINNIE: | Be patient, Mother. It's coming. |

| MOTHER: | Fancy no claret after such a big important meeting. |

STEVIE: B – big – meeting.

The family again looks to VERLOC for a response. Again, they get none.

MOTHER: Cod for dinner, Mr Verloc. Keep you fighting fit.

 Winnie – Winnie – Winnie – no mustard, Winnie? You can't expect a man of Mr Verloc's refined sensibility to swallow a piece of cod without any mustard.

 She's forgotten the little spoon that goes with it.

STEVIE: S – sorry.

MOTHER: I mean, standards slip and what are you left with? Difference between us and the savages, isn't it?

STEVIE: S – savages.

MOTHER: Spoon for the mustard.

 Winnie – Winnie – Winnie!

 What Mr Verloc needs right now's peace and quiet so he can decompose himself after the long day he's just had.

Again, they look to VERLOC; again, no response.

 Mustard pots always make me think of your father, Winnie. We've been married twenty-five years, he said, have this – and handed me a mustard pot. Happiest day of my…life.

VERLOC gets up, and starts shuffling off to bed.

 When you were in France, Mr Verloc, growing up, growing up as a little French boy – when your mother spoke French to you – did she do it in a French accent?

The family look at VERLOC; then –

VERLOC: … I'm not actually feeling very well.

The family watch in silence as VERLOC exits.

MOTHER: Well, I can't possibly imagine what it is that you two have done to upset the excellent Mr Verloc.

STEVIE: S – s – sorry.

WINNIE: It's not your fault, Stevie. You've done nothing. We've done nothing.

7. WINNIE & STEVIE – 1

WINNIE and STEVIE, as children, defend themselves from the blows of their father.

8. OSSIPON & THE PROFESSOR – 1

The PROFESSOR sits in the bar of the Silenus. OSSIPON enters.

OSSIPON: Only just heard. Now – on the street. Some lad flogging newspapers, shouting it out.

Come in here to get a drink.

Then – seeing you…

You. The one person who probably knows what actually…

You have heard about it…?

Look: I don't think I was followed.

So – tell me: was it you?

Did you – give your, you know…your *it* – to someone. Recently, I mean.

Because if you did – if you are involved in this…
episode – then the police will be looking for –

Unless of course they're too cowardly to try to
arrest you because they believe the rumour.

PROFESSOR: Pathetic.

OSSIPON: Absolutely.

PROFESSOR: Not them. You: Ossipon. You can't even ask me
a straight question.

OSSIPON: Course I can. I mean, makes no difference to me
– but – yes, OK then – do you?

PROFESSOR: Don't matter.

OSSIPON: That's not an answer.

PROFESSOR: Don't matter if I've got a bomb strapped to me
or not. What matters is they believe I've got the
balls to actually do it.

OSSIPON: Right, so –

PROFESSOR: And I have got the balls. And the brain. And my
right hand closed round the rubber pouch in my
trouser pocket at all times. Just gotta squeeze the
pouch –

OSSIPON: I see, but –

PROFESSOR: – which activates my detonator; same principle
as the pneumatic shutter for a camera lens –

OSSIPON: Fine, but –

PROFESSOR: – twenty second delay, then –

OSSIPON: Interesting, but –

PROFESSOR: Shut up! SHUT UP. Twenty second delay then
you shut up. Forever. You die. Them, they die
too.

But not you. Not the police. Not none of
you got the balls to stop me, to think outside
conventional morality. You all depend on life. If
you wanna become a man you've gotta cherish
death.

OSSIPON: You sound just like any one of our comrades.

PROFESSOR: Me? Like – me? Like – me? Like – one of your
comrades? Chief Inspector Heat: he's like one of
your comrades. Him, yes. He was in here earlier.
Staring at me, pig eyes twitching with questions:
*arrest me or not – risk it or not? What about my
reputation? What about my salary? What about my
pension?...* Me – didn't even glance back. I was
thinking of one thing and one thing only: my
perfect detonator. He was as insignificant to me
as – can't think of anything insignificant enough
to – yes, I can – you. Terrorist and counter-
terrorist. Insurgency, counter-insurgency. You
prop each other up. Complementary moves in
the same game, underpinned by inertia. Checks
and balances you'd like to think means change
but actually means nothing.

OSSIPON: What is it you do that's so much more effective
than us?

PROFESSOR: Don't you listen? I'm making the perfect
detonator.

OSSIPON laughs.

Can't bear anything conclusive, can you? You
see: not only do I not play your little game, I
don't *play*. I work. Fourteen hours a day. Often
without food 'coz my experiments cost money.

I've worked alone for years. No one's comrade.
No one's son. I am the Professor. Don't have
a name, don't have my own life – I've given
it away for a future I'm not even gonna try to

imagine in case I infect it with the rotten stench of now.

OSSIPON: And you're going to bring about this future by – what? – tinkering with detonators?

PROFESSOR: You got anything half as precise?

OSSIPON: Not yet – perhaps – no, but when we do I'm sure we'll come up with something better than fiddling with gizmos for a bomb that is only rumoured to exist.

The PROFESSOR reveals the bomb concealed inside his jacket to OSSIPON.

Just tell me – all I need to know – did you, or not? Provide the explosives, I mean. That's all I'm trying to – a man was blown up in Greenwich Park this morning. *(Reading from his newspaper.)* Terror Attack in Greenwich Park. Half-past eleven. Foggy morning. Effects of explosion felt as far as *blah blah blah.* Enormous hole in ground. All round fragments of a man's body blown to pieces. Speculation it was an attempt to blow up the Observatory. … That's it. That's all it says and so you can't blame me for wanting to know – I mean, this, it's – it's criminal.

PROFESSOR: You even talk like them.

OSSIPON: Criminal because this is going to affect my – our situation.

PROFESSOR: Inspector Heat and his men gunning us all down; broad daylight; public cheering them on. That's a situation!

'Coz then the rot would have set in. The blood'll be in the water. But you don't get it, do you? Never will. You think: status quo and progress.

You think: savages and civilization. But you should think: the human animal. You should think: predator. You should think: annihilation. We gotta make room for the future. And only explosions make space. Clean, clear space. Madness and despair. Beautiful! Vapours from the pit of death. Beautiful! Caustic, popping bubbles – everything new – beautiful! Explosions are the most lasting thing in the universe. Which is why I'd hand out my stuff to every man, woman, child, foetus and tell them: go shovel it in heaps on the corner of every street of every city of every corner of the globe if I could but I haven't got enough of the stuff – so I can't.

OSSIPON: Then it was you?

PROFESSOR: Yes.

OSSIPON: Yes? You? So I was right. Right. Knew it. Right. Right, well – go on then, describe him to me.

PROFESSOR: Who?

OSSIPON: The person you gave the – you know – the stuff to.

PROFESSOR: Verloc.

OSSIPON: …What?

PROFESSOR: Verloc.

OSSIPON: Verloc? No. No, he's too – Verloc? – no, not the sort for a – not Verloc – no – not a suicide mission; no way it could've been…

Right. Right. But that means – I mean – did he say why – his plan?

PROFESSOR: Wanted to *bugger up* a building.

OSSIPON: But the Observatory has no political flavour at
 all.

PROFESSOR: The empty phrasing of a journalist. I made him
 something that could be carried and deposited
 with a detonation time of twenty minutes. Sent
 him out like a pest into the world of men. Used a
 one gallon varnish can –

OSSIPON: It malfunctioned –

PROFESSOR: No. He must have dropped it.

OSSIPON: It malfunctioned –

PROFESSOR: It did not malfunction.

OSSIPON: It malfunctioned –

PROFESSOR: Sit down!

OSSIPON: – and when they find out it was him – they'll
 think I'm somehow – me – they'll think we're all
 part of some cell – I mean, we are, a cell, totally
 – but not – not – not – not – I mean, being part
 of a movement is one thing, but taking action is
 something else entirely and – me – what am I
 going to – wait: blown into bits – yes! Yes – good
 – says it here – body in fragments – excellent!
 They won't be able to tell who – unless they
 speak to Verloc's wife and – I need to distance
 myself from this whole – I'll speak to my
 contacts in the press. Put out a story we're in no
 way connected to this stupid –

PROFESSOR: Press have already bought their stories from the
 police. Only smart thing to do – for you – would
 be to find his woman – Verloc's woman – pick
 her out from amongst the odious multitudes and
 fasten yourself on to her for all she's worth.

9. VERLOC'S LAMENT

VERLOC: Ladies and gentleman, I used to be like you: lucky. I used to be able to sit, not move, just sit and watch toothless old terrorists and windbag anarchists trading hot air. And while sitting and watching I did some thinking: a thought flew into my head and generated another and before long I found myself buckling under the weight of an entire theory.

And this is it: if you want to blow up the First Meridian, what must be done is…*something.* Something must be done. Because what are we, ladies and gentlemen, without action? Nothing. Action is all the matters. The rest is nothing.

And the members of this cell I've infiltrated – nothing is all they do. Nothing is all they're good for.

And you? Your luck ain't out. You can still sit there. Watching. Doing nothing.

So where does that leave me? Me? Who does that leave me? Me. It leaves…me.

I need to sit down.

10. WINNIE & VERLOC – 1

VERLOC sits in the parlour, his face in his hands.

WINNIE: *(Sings 'Blue Moon'.)*
Blue moon, you saw me standing alone…

She leads VERLOC out of the room.

11. MOTHER

WINNIE, STEVIE and MOTHER in the parlour. WINNIE does housework.

MOTHER: Didn't sleep very well last night. Did you sleep well? 'Course you did, you always do don't you, Winnie? There was something outside my window. Could have been an owl. Or a fox. Or a small child. If it was a small child I hope it wasn't on its own. If I wanted to catch up on my beauty sleep, though, I could do it right here, in this chair. Couldn't I? Actually, this chair could double as my bed. Not just my bed; I mean I don't want to be over-dramatic, but if I died – no, Stevie, I said if I die – if I died, they could bury me in this chair. All I really need, this chair.

Stevie – be a good egg and fetch me my scarf, Stevie.

STEVIE leaves.

I don't know what you're doing Tuesday morning Winnie, but I'm moving out then.

STEVIE comes back in with a scarf.

STEVIE: Sc – sc – sc –

MOTHER: Oh, Stevie your mother's a right numpty sometimes. I said scarf but I meant…my ointment. Be a good boy and get me my ointment? Thank you, Stevie.

STEVIE leaves again.

WINNIE: Why would you do that?

MOTHER: You'll be pleased to know your father may be dead but he isn't forgotten, not by all his old colleagues and friends and employers and strings were pulled and Bob's your uncle

Winnie, I've got myself a lovely lovely lovely little – name does them no justice – not an Almshouse – a… *Charity Cottage*.

***STEVIE* comes back in with a jar of ointment.**

STEVIE: Oi – oi – oi –

MOTHER: I didn't go and say ointment did I when what I meant was…chestnuts. I'm sure there are some chestnuts in the kitchen be a good egg and check for me won't you, Stevie?

Exit STEVIE.

WINNIE: What will people think?

MOTHER: There's a tremendous little park round the corner – if I ever felt the need for an experience of foliage. You can come visit. You'll like it, it's very very very – it's not big. Cosy. Bijou. That's the word. Bijou! Won't have to do much cleaning. And if I do get an uncontrollable urge to start cleaning what a breeze because I'll probably be able to reach everything from this chair. If it fits. I'm going to take this chair. You don't mind, do you? The rest you should keep. Thought about leaving all the furniture to Stevie but we don't want Mr Verloc lying in a bed that doesn't belong to him. Men are proud like that.

***STEVIE* comes back in, empty-handed.**

STEVIE: *(Stammering.)* N… No…

MOTHER: Don't worry, Stevie. Don't worry, my boy. Winnie you didn't – why didn't you brush your brother's hair this morning? Poor egg looks like a scarecrow. Come over here Stevie and I'll brush your –

WINNIE: Upstairs, Stevie.

STEVIE hesitates.

>Now.

STEVIE exits.

MOTHER: I'll be able to see Stevie once a week. Be nice to have a bit of husband and wife time, won't it? He can come down on the tram and change at – oh, he'd have to change. We'd have to find a way of making sure that if he was misplaced somewhere he could be returned to… Perhaps you could bring him down or… No, you'll be too busy, won't you? Didn't think of that.

WINNIE: No. You didn't.

MOTHER: And no point bothering Mr Verloc with this right now, is there? You should tell him after I'm gone.

>I know what husbands are like. I had one, and he had a very very small – all husbands do, they normally have quite a small pot of kindness and as it gets emptier it doesn't fill up again and what with Mr Verloc looking after Stevie and me… Well, if you want to make the pot last longer…

WINNIE ignores her; starts cleaning around MOTHER's chair.

>They don't grow on trees, men like Mr Verloc.

>Everything wears out, in this world. Just think of my old straw bonnet – the one with the strawberries not the one I got from Maisey Parker after that incident with the chickens – and Mr Verloc's kindness is no different. And if people think badly of you, my dear girl, or the excellent Mr Verloc because I've moved out that's a small price to pay for making sure Stevie's looked after.

>I'm in your way aren't I?

12. THE HORSE BOY

STEVIE is in the parlour.

STEVIE: The whole world is made of circles. When I was little, littler than I am now, my dad who's dead would hit me in the face with his hand and his palm, as it came towards me, it was a big circle. And this man, who took my mother away in his carriage, instead of a hand he had an actual circle. When my mother saw him she said –

Nothing from MOTHER.

 And she's never normally short of words. But what she was thinking was: *How can that big-faced cabman drive a carriage when he's got an iron hook for a hand?*

 And the cabman, seeing the look on her face, shouted –

CABMAN: Who are you? Queen of Sheba? Think they'd give me a licence if it were any sort of impediment? I been driving a cab twenty years and not one soul's complained.

WINNIE: Ever had an accident?

CABMAN: Accident!

The carriage ride begins.

STEVIE: The whole world is made of circles. Circles that spin and wobble and grow and shrink and it makes you feel like falling over sometimes 'coz there's too many of them – crossing over, making little crescent moons, bumping into each other, bashing each other, cutting each other up and it's too much. But in my head, there, it's different: beautiful straight lines, sharp angles, in nice, clear, open spaces.

And it's the difference between the outside world and what's going on in my head that splits everything in two for me. What I know is happening, and what everyone else says is happening. Like my sister thinking:

Three-and-sixpence for this? The last cab drive of our mother's life?

But actually saying –

WINNIE: This isn't a very good horse.

STEVIE: And not just her. Me, too. I'm thinking: this horse – the circles of its eyes and the circles of its hooves shouldn't be so big compared to the rest of it. Its back as thin and narrow as a plank. Its ribs – a whole necklace of circles that I shouldn't be able to see – its harness flapping – the wheels of the carriage turning like they're crushing something – the carriage glass rattling and jingling – but all I say is –

(Struggling to get the words out, stammering.) *Don't!* … You mustn't. It…*hurts.*

The cabman's whip makes a giant circle in the air and the horse says –

The horse is silent.

But what it's thinking is –

HORSE: What sort of animals deposit their mother in an almshouse? People discard each other. Not me and my Master. We're in it together, for the long run. Not that I can run anymore. But together until one of us is meat for the butcher.

WINNIE: Stevie! Get back up on the box.

STEVIE: **(Struggling.)** *… No. … No. … Must walk.*

My sister says:

WINNIE: Mr Verloc won't like this.

STEVIE: But what she's thinking is:

 Stevie'll get lost!

 I say:

 Must walk. Too...too heavy for horse.

 But I think that I don't want my sister's husband
 upset and I get back up on the box.

CABMAN: Ow'd you like to sit behind this 'oss up to two
 o'clock in the morning p'raps? 'Ow would you
 like... Till three and four o'clock in the morning.
 Cold and 'ungry. Looking for fares. I'm a night
 cabby. I've got to take out whatever beast they
 will bloomin' well give me at the yard. I've got
 my missus and four kids at 'ome.

STEVIE: I'm thinking that when I was little, littler than
 I am now, and the circle of my dad's palm
 whacked me into some dark corner my sister
 would come and carry me off into bed with her
 – to heaven, she'd carry me off into heaven.

 But what I say is:

 (Struggling.) Bad... Bad...

CABMAN: You got it wrong, boy. I ain't bad. Can't say if
 the world's bad but I do know it ain't an easy
 place. But this 'oss 'ere: he ain't lame; he ain't
 got no sore places on 'im. It ain't an easy world,
 no. 'Ard on 'osses, yes, but dam' sight 'arder on
 poor chaps like me.

STEVIE: I want to carry you and your horse into bed with
 me!

 That's what I think, in the clear open space of
 my head.

But what I say is: *(Struggling.)* … *Poor!* … *Poor!*

My sister's thinking:

Cab of death! Steed of apocalyptic misery!

But she says:

WINNIE: Come along, Stevie. You can't help that.

STEVIE: Poor cabman, too! Is this how things must be? Is this how circles work? One form of wretchedness feeding upon the anguish of the other? The poor cabman beating the poor horse in the name of his poor children at home?

Shame! Bad world for poor people!

WINNIE: Nobody can help that.

STEVIE: The wheels are crushing something. Grinding the man into the horse into the man into the horse into – round and round until it makes you want to fall over or start spinning and all I want is to make it stop. Please stop. Stop! STOP!

WINNIE enters the parlour and calms STEVIE.

P – poor horse.

WINNIE: The horse was fine.

STEVIE: P – poor man.

WINNIE: None of that has anything to do with us. It's nothing to do with you and me.

STEVIE: You and me.

WINNIE: Nothing.

STEVIE: B – bad world.

WINNIE: If you look long enough at anything it seems that way. So you mustn't.

STEVIE: Sorry.

WINNIE: You mustn't look.

13. VERLOC RETURNS (AND LEAVES WITH STEVIE)

WINNIE is in the parlour, alone. VERLOC enters holding a package.

WINNIE: He's a different boy since Mother's left. He still works as hard. He really is helpful.

VERLOC: I'm going out for a walk.

WINNIE: Take him with you.

VERLOC: What? No.

WINNIE: It would do him good.

VERLOC: I've got quite enough to worry about right now thank you very much.

WINNIE: He'll stick to you like a puppy.

VERLOC: No. He'd… What if he got lost?

WINNIE: He knows how to find his way back.

VERLOC: What did you say?

WINNIE: I said –

VERLOC: Yes. Very good. Yes.

VERLOC leaves.

14. HEAT & THE PROFESSOR

The PROFESSOR sits in the bar of the Silenus. Inspector HEAT enters.

PROFESSOR: Chief Inspector Heat. Clocked off for the day?

HEAT: Don't worry – it's not you I'm looking for.

PROFESSOR: Worried? Me?

HEAT: But when the time does come, I'll know exactly where to find you.

PROFESSOR: You worry. Not me. Worry that by the time they get 'round to printing your obituary they still won't have been able to sort your body parts out from mine. Imagine that: you and I cheek by jowl in the same pit of earth for black eternity.

HEAT: Got nothing new to say to scare the little children? Oh well, you'll have plenty of time to work on new material once I've put you inside.

PROFESSOR: Go on, then: no time like the present. Arrest me. Come on. Perfect opportunity for a brave man like you. A man of real conviction. Arrest me. Arrest me – then I'll detonate this bomb, count twenty seconds, and you and me and all these people slumped in their chairs in the darkness – their heads, flicked from the mantlepiece of their shoulders, will end up as grimy smudges on the back wall of this room. And you – just think of the headlines, the extravagant funeral, the bonus pension pay-out for death in the line of duty.

HEAT: Were I to arrest you now, without the necessary evidence, I'd be no better than you are.

PROFESSOR: Oh yes: the game.

HEAT: And you can be sure that our side is going to win.

PROFESSOR: Sides and rules and the game – you don't even know – you will never even begin to understand – what is actually being fought for.

HEAT: Tell me, then.

No response from the PROFESSOR.

> Well, whatever it is you might as well surrender now. Sooner or later you'll realise there are too many of us for you to succeed. Government. The departments and institutions put in place by the people, for the people. We are everything that is right. You are not.

PROFESSOR: The simplicity of your thought must be very comforting.

HEAT: I haven't got time for this.

PROFESSOR: I work – do you understand that?

HEAT: Lunatic.

PROFESSOR: I work.

15. WINNIE & STEVIE – 2

WINNIE and STEVIE are children again. WINNIE presses herself up against a door, stopping their father from getting into the room in which they have been hiding. Their father tries to break down the door with a stick, but fails.

16. VERLOC RETURNS ONCE MORE

WINNIE is alone in the parlour, preparing dinner. VERLOC enters.

WINNIE: Everything's wet. Where did you go?

> You're shaking. You'll be in bed sick for the next few days.

VERLOC: Unlikely.

> I went to the bank. Because... I've drawn out all our money.

WINNIE: Why?

VERLOC: We're emigrating. To California.

WINNIE: You've got a fever.

VERLOC: Or maybe France.

WINNIE: Take off your wet socks and put your slippers on.

VERLOC: Or Brazil. I'm unlikely to get a cold in Brazil.

 You trust me, don't you?

WINNIE: If I didn't trust you I wouldn't have married you.

VERLOC: Then take your husband at his word when he says – when I say we may have to. Leave the country, I mean.

WINNIE: Why? The house is comfortable.

 And Stevie doesn't like change.

VERLOC: Always that boy.

WINNIE: If you go, you go without me.

VERLOC: You know I wouldn't.

WINNIE: Because you'd miss me too much.

VERLOC: *(Handing her an envelope from his coat pocket.)* There's enough here – look after it – there's enough here for us for an easy life, somewhere where there's less…disturbance.

WINNIE: *(Taking the envelope.)* Go upstairs and rest.

VERLOC: Yes.

WINNIE: And when Stevie gets back we'll eat.

 (VERLOC exits.)

 …Where's Stevie?

17. THE UNEXPECTEDLY EXPLODING BOY (HEAT)

As HEAT delivers his report, WINNIE helps STEVIE into his coat. Once STEVIE's dressed for going out, VERLOC enters and then leads him off.

HEAT: I began the investigation immediately. Went directly to the hospital and was shown bits and pieces of rag and flesh and bone all heaped on a waterproof sheet. Everything scorched. Blood-stained. Raw material, you might say, for a cannibal's feast.

A local constable – first man on the spot after the explosion – says to me: *He's all there – every bit of him.* Says he saw something like a flash of lightning in the fog then ran towards it fast as his legs would carry him.

Unpleasant turn of phrase: it was the suspect's legs that he found first. Picked them up, on instinct, he says, then put 'em down again and realised he'd need a shovel.

Two men had been seen coming out of the station after the up-train had gone on. One large, the other slight. Witness couldn't tell if they were together, but remembered the slight one carrying a tin varnish can in one hand.

One of the only recognisably intact parts in this pile of – well, frankly, a pile that could easily be mistaken for what you might see a butcher selling as a cheap Sunday dinner – is a foot. It's the foot of a slight man.

It's with great reluctance I start picking my way through the stew in front of me. I don't throw up, mind, like some of the folk that first arrived at the scene of the incident. I observe that there's bits of gravel, bark and splintered wood mixed in with – with the man.

It was on a root of a tree – this is the young constable's speculation – that the man must have tripped. Must have tripped and dropped the device he was carrying and it must have gone off right under his chest. Solid reasoning, in my view.

Solid reasoning would also tell us that the death was instantaneous. I can't help but feel, though, that the violence of destruction that can reorganise a man into a heap of nameless fragments has a cruelty to it; a cruelty that makes me believe no human body can reach this state of disintegration without passing through inconceivable agony.

And not just agony because, based on material I have read in popular publications, there is reason to believe that the instant of death does not have the same qualities as an instant of life. The instant of death is longer, according to men and women variously rescued from the jaws of death; sufficiently long to live your entire life once more so that when you do reach the final end point, you could be said to have lived two lives – double the regrets, double the mistakes and pain and all the sour episodes that constitute a human life.

One of the pieces of rag that I pull from the heap of shredded parts in front of me is a strip of dark blue cloth that must have previously formed the collar of an overcoat. And on it, I see writing. An address. Useful for a man if he's going to get lost. Lost in life, I mean. Not in death.

18. HEAT & WINNIE

WINNIE is in the parlour. Inspector HEAT enters.

WINNIE: My husband's not well. Come back tomorrow.

HEAT: What makes you think I want to see your husband?

WINNIE: Don't you?

HEAT: I do, in fact. I do.

Are you not going to ask who I am?

No response from WINNIE.

I'm Chief Inspector Heat of the Special Crimes Section.

WINNIE: That's fine. You can still come back tomorrow.

HEAT: Or I could speak to you, now.

WINNIE: About what?

HEAT: Same thing I want to speak to your husband about. Perhaps he said something to you about it when he came in?

WINNIE: He didn't.

HEAT: I see. Well, then. In that case: I'd like to ask you about the overcoat that was recently stolen from you.

WINNIE: We've had nothing stolen.

HEAT: Really? Well, I happen to have in my possession a dark blue overcoat with the address of this house written on the inside of the collar.

WINNIE: Stevie's.

HEAT: Who?

WINNIE: Why have you got my brother's coat?

HEAT: Your brother?

WINNIE: It's his coat.

HEAT: And where is he now, your brother?

WINNIE: Gone out.

HEAT: Heavy fella, your brother?

WINNIE: No. He's little.

HEAT: Good.

(Taking the piece of cloth from his pocket.) This his, is it?

WINNIE: Why's it been torn out like that?

HEAT: You confirm it's his?

WINNIE: Yes. That's from Stevie's…

HEAT: So you're telling me you know nothing about this bomb affair?

WINNIE: What bomb affair?

HEAT: I see.

WINNIE: What bomb affair?

19. VERLOC & HEAT

Continuous – VERLOC enters the parlour.

HEAT: Out of bed, Verloc?

WINNIE: What bomb?

VERLOC: Leave us, Winnie.

Get out! Get out!

WINNIE exits.

HEAT: Two men were seen entering the park: one slight, one larger. This was found amongst the remains of the slight man.

VERLOC: Let me see that.

HEAT: You were the large man. You are the large man.

VERLOC: She must have sewed it into his collar.

When I heard the bang I started running.

HEAT: The bang surprised you?

VERLOC: It came too soon.

HEAT: Blown to small bits. Limbs, gravel, fingers, bones and – all mixed up together. Had to use a shovel to gather him up. We believe he tripped. In that fog. On the root of a tree.

VERLOC: The boy was a half-wit.

HEAT: It strikes me you're the one who's dim, Verloc. Why would you suddenly decide to do something idiotic like this?

VERLOC: If you take me away, somewhere safe, I promise to tell you the whole story.

HEAT: No. Mr Verloc. No. Firstly, if we arrest you you'll cease to be of any use to us. Not with the anarchists, but with your friends at the Russian Embassy –

VERLOC: I don't know what you mean.

HEAT: You don't think that just as you keep your eyes on certain people for us, we don't have eyes on you too? You'll be able to work even better for us now you've got an actual – well, achievement of sorts – chalked up to you. Secondly, if we took you away or locked you up it'd soon reach

the newspapers – and how would it look if the public found out that the man responsible for this is also on the police payroll?

VERLOC: I won't be safe. I'll need protection.

HEAT: I have every confidence that a man of your experience knows how to look after himself. And from the perspective of the law, this is at worst a case of criminal damage to Crown Property. But as the actual perpetrator is clearly dead there is nothing further for us to look into. Nothing to look in to. Do you understand?

In many ways, Verloc, this is an excellent result for us.

Well done.

Inspector HEAT exits.

20. WINNIE & VERLOC – 2

WINNIE and VERLOC in the parlour.

VERLOC: I hope you know that I never meant any harm to the boy. Him exploding like that – it was a pure accident. As much an accident as if he had been run over by a bus while crossing the street. The way back from the Observatory only takes fifteen minutes and the device was set to go off after twenty. You see, Winnie? Not my fault. I mean, if you think about it – he's much more of a nuisance to me dead than he ever was alive.

Winnie – why aren't you looking at me?

That policeman's upset you, hasn't he? Blurting it out like that. Well, this isn't particularly nice for me either, you know. All today, knowing I'd have to tell you what happened at some point.

Look, why don't you go to bed? What you want is a good cry.

Sulking like this won't bring him back, you know. Just think: it could have been me, your husband.

And that maniac at the Embassy – wanting to cut me off, throw me out to rot in the streets for a joke – a man like me! After all that I've done for them. Some of the highest in the world have got me to thank for walking on their two legs to this day. Dozen – dozens? – hundreds! of these revolutionists and anarchists I've sent off, bombs in their pockets, to get themselves caught crossing the border. That's the man you've married, my girl.

You have to pull yourself together, Winnie.

And actually, if you want to start talking about who's to blame then really it's as much your doing as mine. You've killed him as much as me. It was you who shoved him in front of me – *take him on a walk, he's so useful, he'd do anything for you* – well I did and in the end he wasn't so useful after all.

Was he?

Look at me, Winnie! I'm not angry with you. Look at me. You have to pull yourself together. What's done can't be undone.

Winnie, you could at least look at a man.

21. MURDER

Continuous – WINNIE and VERLOC in the parlour.

VERLOC: … Winnie?

 … Winnie?

 … Winnie?

 Come here.

WINNIE **stabs** *VERLOC.*

22. WINNIE & OSSIPON

OSSIPON enters VERLOC's house. He finds WINNIE alone.

WINNIE: Mr Ossipon. What are you doing here?

OSSIPON: I've seen the papers. Headline news. Where were you going?

WINNIE: I don't know.

OSSIPON: Right. Well. I'd be… Happy to help you in – in your trouble.

WINNIE: My trouble?

OSSIPON: I'm no fool – read the evening paper – pieced it all together and immediately started wondering whether you – I've been fond of you beyond words from the moment I first saw you.

WINNIE: I thought so.

OSSIPON: You read it in my eyes?

WINNIE: Yes.

OSSIPON: But I couldn't guess how you – you were always so distant.

WINNIE: What else did you expect? I was a respectable
 woman. Till he made me what I am.

OSSIPON: I never thought he deserved you.

WINNIE: He cheated me out of seven years of life.

OSSIPON: You seemed to live so happily with him. Seemed
 to love him.

WINNIE: Love him!

OSSIPON: I was surprised. Surprised and jealous.

WINNIE: I was a young girl, Tom. I was tired. I had two
 people depending on me – two people – mother
 and…the boy. Stevie was more mine than
 mother's. Stevie was mine. You can't understand
 that. No man can understand it. *He* didn't
 understand that.

 Do you know what he was, that friend of yours?
 He was a devil.

OSSIPON: I didn't know.

WINNIE: And now he's dead. Just as you guessed. You
 guessed what I had to do.

OSSIPON: How did you first hear about it?

WINNIE: A chief inspector came – oh, Tom! – they had to
 gather him up with a shovel.

OSSIPON: The police came already?

WINNIE: He showed me a piece of overcoat, and…

OSSIPON: And?

WINNIE: He went away. The police are on Verloc's
 side. Maybe because – maybe because of the
 Embassy people.

OSSIPON: What Embassy?

WINNIE: The man he hated.

OSSIPON: What are you talking about?

WINNIE: Hide me somewhere till the morning.

OSSIPON: I can't take you where I live. I share the room
 with a friend.

WINNIE: But you must. Don't you care for me at all? …
 Don't you?

OSSIPON: I suppose it might be possible perhaps to find a
 safe lodging somewhere, but the truth is – well,
 we revolutionists are not rich.

WINNIE: But I have money. Tom! Let's go now.

OSSIPON: How – how much have you got?

WINNIE: All of it. Everything he had in the bank.

OSSIPON: But – right. Right – how'd you manage to get it
 already?

WINNIE: He gave it to me.

 Don't let them take me, Tom. You must kill me
 first.

OSSIPON: They won't be after you.

WINNIE: Haven't you guessed what I had to do?

OSSIPON: Calm down. There's still plenty of time to make
 a train from Waterloo.

WINNIE: I forgot to shut the door. Go in and lock it – or
 I'll go mad.

OSSIPON: Where's the money?

WINNIE: On me! Go, Tom. Quick!

OSSIPON: I'll do it just stop shouting.

OSSIPON *sees* VERLOC's *dead body.*

You did this by yourself?

I wouldn't have believed it possible. No one would.

WINNIE: I'll work for you. I'll slave for you. I'll love you. I won't ask you to marry me. Please don't let them hang me.

OSSIPON: Was he asleep?

WINNIE: No.

After taking the boy away from me to kill him – my loving boy – I wanted to leave. But then he said, like this: *Come here.* Come here, he said, after ripping out my heart to smash in the dirt.

OSSIPON: So it wasn't Verloc, it was the degenerate.

WINNIE: Blood and dirt.

OSSIPON: Get up. We need to go or we'll miss the train. We'll go to Paris first, and then…

When we arrive you must go into the station ahead of me, as if we don't know each other. I'll get the tickets and slip yours into your hand as I pass you. Then you go into the first-class ladies' waiting-room and sit there till ten minutes before the train starts. Then you come out. I'll be outside. You go in first on the platform – still as if you didn't know me. There may be eyes watching and I'm known. Alone you are only a woman going off by train. With me, you may be guessed at as Mrs Verloc running away. Do you understand?

I ought to have the money now. For the tickets.

Here we are. Get out first, and walk straight in.

In a train carriage.

> Don't worry about the guard – I told him not to
> let anybody into our compartment.
>
> He was an extraordinary lad, that brother of
> yours. Most interesting to study. A perfect type
> in a way. Perfect.
>
> It's almost incredible the resemblance there is
> between you two. Yes: he resembled you.
>
> Go over into the other corner of the carriage,
> away from the platform. That way you won't be
> seen.

WINNIE: I'll live all my days for you, Tom.

*OSSIPON jumps from the moving train, leaving WINNIE alone
in the carriage.*

23. OSSIPON & THE PROFESSOR – 2

The PROFESSOR and OSSIPON are in the bar of the Silenus.

PROFESSOR: Source of all evil. The weak! They are our
 sinister masters: the weak, the flabby, the
 silly, cowardly, the faint of heart, slavish
 of mind. They have the power. They are
 the multitude. Theirs is the kingdom of the
 earth. Until they are exterminated – nothing.
 Every taint, every vice, every prejudice, every
 convention must meet its doom. I've suffered
 enough from this oppression by the weak. Me.
 I am the force. Follow me, Ossipon. No God!
 No master! The strong must obliterate this
 hell created by the weak. But time. Give me
 time! And we can – join me, Ossipon – we can
 exterminate this multitude – too stupid to feel
 either pity or fear.

(Toasting.) To the destruction of what is!

What's the matter with you? Sitting at your beer like a dummy? Drink. Drink and be merry, for tomorrow we die.

I said: tomorrow we die.

What is it? Trouble with your collection of girlies?

Got to be something wrong with a man who chooses to spend time with me. Then again, I hear that nowadays you'll spend time with anyone who has a beer in front of them. I hear that nowadays you've got money to splash about.

Talk. You're normally full of words.

What's in that?

OSSIPON: Nothing.

The PROFESSOR snatches OSSIPON's newspaper from him.

PROFESSOR: *(Reading.)* *An impenetrable mystery seems destined to hang forever over this act of madness or despair.*

OSSIPON: There's nothing – it's ten days old.

PROFESSOR: *(Still reading.)* *Suicide of Lady Passenger from a cross-Channel Boat.*

OSSIPON takes the paper back and puts it in his jacket pocket.

OSSIPON: Damn you.

PROFESSOR: You're an idiot. But you are funny.

 (Getting up.) Work.

OSSIPON: Wait! Madness and despair. Tell me – what do you know about them?

PROFESSOR: They are a force. This world is mediocre, limp, without force. And force is a crime in the eyes of the fools, the weak and the stupid who rule the roost. You are mediocre. You have no force. Verloc – whose affair the police have hushed up so nicely – mediocre. Everybody is mediocre. All passion is lost. Madness and despair – if only! Give me that for a lever and I'll move the world.

OSSIPON: Take it off me.

PROFESSOR: What?

OSSIPON: The money I've…come in to.

PROFESSOR: I'll send you some bills. For certain chemicals I need.

OSSIPON: I want you to take it all.

PROFESSOR: Madness and despair. To regenerate the world.

But all of them. Numerous as sand on the seashore. Totally inert. The sound of our bombs is lost in their passive immensity without even an echo.

This Verloc affair, for example. Who even thinks of it now?

24. THE CABINET OF DESIRES (REPRISE)

VERLOC: Ladies and gentlemen – *ladies and gentlemen* – that is it. What I mean to say is: that was it. That will be it. Innumerable circles suggesting chaos and eternity. Suggesting, but really –

Winnie.

The curtain opens on the Cabinet – WINNIE is seen motionless, floating underwater.

Thank you, Winnie.

The curtain closes on the Cabinet.

Suggesting chaos and eternity. But really – well, a kind of sacred inertia.

So, ladies and gentlemen, my advice to you is to forget it. Everything. Especially everything you've just seen. Forget the men and women you've seen tumble from behind these curtains. *Bang!* Forget the messy trails they've left in the mud. *Boom!* Because what is human history, ladies and gentlemen, if not the confused, spastic patterns wounded bodies leave as they drag themselves across the earth? Patterns of blood and dirt obliterated completely when explosions send clods of soil and clods of man into the air.

So if anything we've said or done has upset, disturbed, provoked or even entertained you, we beg your pardon and ask you to remember this: the only thing that any explosion ever really leaves is…nothing. *Nothing* must be done. Except, perhaps –

WWW.OBERONBOOKS.COM